MOTHER TIME

OTHER BOOKS BY
JOANNE ARNOTT

Steepy Mountain: love poetry
(Kegedonce Press, 2004)

Breasting the Waves: On Writing & Healing
(Press Gang, 1995)

Ma MacDonald
(Women's Press, 1993)

My Grass Cradle
(Press Gang, 1992)

Wiles of Girlhood
(Press Gang, 1991)

MOTHER
time

POEMS NEW & SELECTED

Joanne Arnott

RONSDALE PRESS

MOTHER TIME
Copyright © 2007 Joanne Arnott

RONSDALE PRESS
3350 West 21st Avenue
Vancouver, B.C., Canada V6S 1G7
www.ronsdalepress.com

Typesetting: Julie Cochrane, in New Baskerville 11 pt on 13.5
Cover Design: Julie Cochrane
Cover Art: Marie-Micheline Hamelin, "Creation at Its Best"
Author Photo: Eszther Szekely
Paper: Ancient Forest Friendly Rolland "Enviro" — 100% post-consumer
 waste, totally chlorine-free and acid-free

Ronsdale Press wishes to thank the following for their support of its publishing program: the Canada Council for the Arts, the Government of Canada through the Book Publishing Industry Development Program (BPIDP), and the Province of British Columbia through the Book Publishing Tax Credit program and the British Columbia Arts Council.

Library and Archives Canada Cataloguing in Publication

Arnott, Joanne, 1960–
 Mother time : poems new & selected / Joanne Arnott.

ISBN 978-1-55380-046-0

 1. Motherhood–Poetry. I. Title.

PS8551.R773M68 2007 C811'.54 C2007-901017-2

At Ronsdale Press we are committed to protecting the environment. To this end we are working with Markets Initiative (www.oldgrowthfree.com) and printers to phase out our use of paper produced from ancient forests. This book is one step towards that goal.

Printed in Canada by Marquis Book Printing, Montreal

This book is dedicated to the mothers of the world

to my children, each one a teacher, each one a gift:
Stuart
Harper
Theo
Isi
Flora Jo
Jules

to the dads
Nick
Brian

&

to my friend
Flo Robertson

ACKNOWLEDGEMENTS

Some of these poems previously appeared in my earlier books, with thanks to Press Gang Publishers and to Beth Brant, for bringing us together. Others have appeared in the following: *Miscegenation Blues: Voices of Mixed Race Women*, Carol Camper (Sister Vision Press, 1994); *Spider Women: A Tapestry of Creativity and Healing*, Joan Turner & Carol Rose (J. Gordon Shillingford Publishing, 1999); *Native Poetry in Canada: A Contemporary Anthology*, Jeannette Armstrong & Lally Grauer (Broadview Press, 2001); and in *absinthe*; *Carnegie Newsletter*; *Contemporary Verse 2*; *Fireweed*; *Gatherings*; *Poetry Canada Review*; *Prairie Fire*; *Room of One's Own*; the *Province*; *This Magazine*; and *Windsor Review*.

The introduction contains quotations from "You Have to Own Yourself: An Interview with Maria Campbell" by Doris Hillis, originally published in *Prairie Fire*, Vol IX, No 3, Autumn 1988. The poem "Enchantment & Freedom" contains the words "Given birth but not nourishment, we die" by Lui Jo, as channelled by a Taoist priest at Po Yuen Taoist Tan, Vancouver, 1986.

Another version of "Old MacDonald" was published for children under the title *Ma MacDonald* (Women's Press, 1993), with illustrations by Mary Anne Barkhouse. "Our Mother" was previously published as "Heretic."

I would like to acknowledge the financial assistance of the Woodcock Fund through the Writers' Trust for moving me to a better place (literally) so that I could complete this book. Some of the manuscript work and writing was also done while I was supported by a grant from the Canada Council for the Arts — my thanks and warm regards.

CONTENTS

MULTIPARA III

GRANDE MULTIP

INTRODUCTION:
RAGS INTO RICHES

*There is no such thing as a bad experience, and
there's no such thing as anger being bad, because
every emotion we're given is a teacher. There's a
reason why we're given those emotions.*

— MARIA CAMPBELL

This is a collection of new and used, or rather, new and selected
poetry. I have not attempted to choose "the best" poems found
in my previously published books, no more than a parent would
choose his or her "best child." Nor have I organized this book
in relation to a poet's landmarks. Beginning in 1996, I began to
pull the threads of work written from a mother's perspective
from the weave of childish and girlish and citizen-of-the-world-
ish perspectives, and to build a new compilation of work using
these scraps. A dozen pregnancy, birth and mother-related
poems from my first three books are here joined with new
and/or unpublished work, and organized around the landmarks
of a mother's life: *primipara* (first birthing), *multipara* (subse-
quent birthings), and *grande multipara* (more than five birthing

experiences). Into this mix I have added a section, *interregnum* (the time between the death of one king and the election of another), to represent my years as a single mother.

A poet's sense of what is important and what is beautiful sometimes diverges dramatically from the more open, overarching and practical concerns of a mother. The external elements of this mother's journey are only lightly sketched; the inner struggles, however, proved a fascination for me, and are amply documented. These poems were written over a twenty year period, 1985 to 2005. Through these two decades, I spent a solid five years pregnant, twelve years breastfeeding, and twenty years parenting the young. I have given birth six times, at home with my family, attended by midwives. Two years were spent in struggle over custody of my first four sons, with one month of complete separation from all four children. Through mediation and negotiation, a joint custody arrangement was developed which has stood us in good stead, and allowed the friendship and family feelings between ex-partners to resurface. In my fifth year as a single parent, I was caught up in courtship once more, and quickly married.

All of my children live at home with me, half-time or full-time, to this day: one is currently pre-school, two are in elementary school, two are in high school, and one is working full-time in the labour force. I have one daughter and five sons.

The Latin term *primipara* is literally defined as "she that has brought forth, foaled, whelped, littered, etc., for the first time" (Lewis & Short). Although such definitions bring me pleasure, and I frequently turn to my tattered Oxford dictionary, I do not in this collection try to capture either "mother" or "time" within any particular confines or limitations. "Mother" and "time" — the two endlessly interact, an ongoing medley of life and becoming.

By separating the mother poems from those of girlhood, many of the tales of abuse received are left behind. The harm taken by that heady combination of Roman Catholic teachings

and my real world experiences as a mixed blood girl-woman led to the efforts toward healing found in many of these poems. I was both soothed and influenced by concepts of the divine female, found in several cultures, and Chinese medical concepts and religion. Katherine Anne Rabuzzi's *Motherself: A Mythic Analysis of Motherhood* had a positive impact, despite her lack of ease with the poor, presenting the mother's journey as an heroic one. Beth Brant, whose "sweetgrass hair, moss eyes" show up in these pages, gave me permission to live in my skin, and to write from that place. Maria Campbell's work, including the interview with Doris Hillis published in *Prairie Fire* in the late '80s, has both led me and fed me: "When you look at our history, as women," she said, "regardless of our culture, it's terrible what's been taken away from us."

My desire as a poet has been twofold: to observe carefully my passage through what seemed to me to be a largely undocumented landscape, and to use poetic expression to recapture and re-synthesize my self, in all of her shards and slivers. After years of contemplating the destruction of female pride and power within the generations of my family, I wrote the poem "Mother Time" as a new job description, a revisioning of a mother's work, away from the rebellious "not this, not that" approach of my first decade of parenting. Although it might read as an historical piece, it has stood me in good stead. Over the years, as my understanding of my historical place has filled out, so too has my compassion for those who raised me.

Although neither a quilt nor a rag-woven rug, this collection bears a resemblance to both of those forms of mother arts. By weaving these poems together, I have intended to make something that will be useful. You do not need to have given birth to enjoy this poetry. You do not need to be a mother. For those who are mothers, here is an opportunity to compare notes. Have your pregnancies been heavily occupied by medical personnel who over-rate their concerns and need for control, or was your life saved by these same personnel in heroic clothes? Did you

feel supported, informed, even cherished by your caregivers? In later years, were your teen-aged sons handcuffed and tasered by sadistic "peace officers"? Or were their lives transformed by a human, dressed as a police man, being touched by a human, dressed in criminal clothes? Our stories, spoken truly, are essential: food and drink, fresh air, room to grow.

Through listening and telling, we weave our individual rags into riches shared.

<div align="right">

Joanne Arnott
January 2007

</div>

PRIMIPARA

East Vancouver & Downtown Eastside

1985–1989

Domain

sitting on a park bench
my body unfurls itself as if
it were my father's, on a couch,
fingers lead arms out across the long
domain;
this is all mine, the body says,
knuckles brushing the furthest edges
of space

Change Herself

first my single woman's
scrawny form takes on
roundness among the angles,
my single woman's mind explores
the meaning in being more —

where my borders are
and the center of balance
pulled by unrelenting change,
secrets pulled from covert muscle
secrets leap with energy and blood
through opened channels,
flush about my being,
tumble out of disturbed flesh,
and materialize in dreams —

labour intensifies the process
labour, the real shakedown —
birth
is terrifying
for i cannot say no to the infant,
but to say yes
is to lay the mind open
to the whole of my unabsorbed life
stashed away in my body

Bitch & Destroyer

bitch and destroyer
brooding inside me
an elephant matriarch trumpeting
anger and grief

a belligerent moon
stamping off
across stars
trampling zodiac
heaving tides and blood
spewing light
spitting down silver
and ivory light
giving as i must give
to those who must take
and rasping
rasping the night

Umbilicus

This is the place
where the rage came through.
A placenta pumping
powerlessness, placating.
Implicating.
With the first blood, webbing the spell
 of compromise.

Why should I forgive?
Under what guise
was I brought to this life, to provide
what kind of cloud, excuse
what weakness, be
whose burden so abandoned
at the root?

I shall be a ruthless mother
and an all-compelling self,
nonrighteous,
unstubborn,
true.

This is the place
where the rage came through.

Trying to kill that rage
was to withstand her absence.

Numbness wearing, and the trade
for her qualified presence

and love. She took me in
as I longed for her to do

when I came to her.
 What of Demeter's love?

This is the place
where the rage came through

I have sought among women
for a touch of you

but no one has fought for my life
or come chasing after.

Now again I am pregnant,
this time, with child.

I can choose from

two
worlds: one

where each child is
abandoned by her mother.

Or another, where a woman's commitment
 changes the earth.

 Why be kind?

However imperfect your back, I was formed
cupped at the base of your spine and
curled in your pelvis.

However reticent your hand,
I have clasped it more than once
and pulled myself
nearer your body,
nearer your mind.

I scramble across you.
I leap from your shoulder.

But this is the place
where the rage came through.
I have hungered for a touch that is raw,
is new

I have hungered for a strength
in myself and in you

why should I forgive?
Under what guise
was I brought to this life?

to scour away
the empty pain
of no-commitment.

Poverty

1

You are of my blood, you brat
your heel thrust against
my eye
you put a finger in my mouth
and I bite

2

Grappling with private property:

out for a walk in the sun, we meet
two kids with a boat by a lake

they set the boat on the water,
push off, clamber in

they are
set free upon the waves

but we
are not

you want to go with them,
I intervene

I hold you
in my arms
on the shore

each of your fingernails digging
into my face
my throat

I am containing
your rage

I am embracing
your fierce rage

I am absorbing
your rage and your grief

and I'm sorry

3

I smile when I see you approaching
and you shout at me NO
NO

but it's not the way you think:
I would give you a thousand boats
a thousand airplanes

I would cause
all of the children to share
and the adults, too

I would put the damned
bandage
on your ear

if it could stop
the aching

4

My private property:

my father's violence
the flinching of my sisters

my son's fingers digging
into my face

my foolish idolization
of an absent mother:

these are the things
i own

these are the things
i don't
have to share

these are my private
possessions:

touch them
I'll kill you

White Solids, Pink Shadows

He gets me where I'm most vulnerable,
in bed, early in the morning,
sucking on my breasts and sprawling
all over my body.

You're too heavy for me,
I mumble.
Get off. Move over. Lay
beside me. No,
he wants to do it just
like
this.

The failing brush with intimacy turns into
early morning pushing and shoving,
I end up
telling him to fuck off and
leave me alone. *Just get the hell*
out of my room
I yell
and then he starts slapping me.

This pisses me off.

Because I am bigger,
because I am stronger,
because I am nine times his age
and sleepy
and madder than hell,
inevitably
I win.

A final stinging slap
raises a welt on his

tiny brown butt, white solids
exactly the shape
of three maternal fingers
that connected real well.

Pink shadows demarcate
the shape of each
distinctive finger.

All morning, all afternoon
endless streams of ancient
moments of terror
and childish despair
wash up through my body.

He recovers hours
before I do,
his laughter ringing
through rooms,
the marks on his body fade
into almost
nothing.

He asks me to nurse and we sit
in an armchair together.

I think about being a child
being grown up.

His tenderness reminds me
never to give up.

I search for some plan of action
that might actually begin

to change things.

The Teaching

I teach the chant to my son:
Earth, I am
Fire, I am
Water, Air, and Spirit
I am

He wants to know
how to spell:
"earth," "water," "fire,"
"spirit," and
"person."

Enchantment & Freedom

When did the chant begin?

How many generations or
thousands of years, shaken
in the womb to the same
damn rhythm
minute in variation, the inflections
sounding out
the same shape
the same meaning
entrained in flesh and form:

> *leave me alone*
> *leave me alone*
> *leave me alone*

The old ones are always dying
bitter with their wishes come true
they lacked faith,
didn't make any plans
about freedom

No small changes are healing
the wounds in myself, the war-torn
nature of my family, and big changes
subtle ones trans/formations
relentlessly draw me
into new alignment
with the single-pointed purpose
of staring down into my own
cadaverous eyes

I have been fighting all of my life
against life for my life

Bending to the task of seeing,
loving, embracing who I am
I find stinking bones and a rage
much larger than myself
an idiot child divine revulsion
and immortal rage,
none of which
I am able to contain,
direct
channel:

I have allowed my mortal form
to become a playground
to the gods

Trampled in youth by parents, siblings,
in adolescence by the vultures in men,
trampled again in adulthood
by the pageants
of gods

What
am I grappling with?

What
have I opened up to?

All I remember
is the chant of my parents
leave me alone, leave me alone
a chant repeated with brothers and sisters
a chant of heartbeat, blood, breathing
a chant of my grandparents, *o leave me alone*

a chant within friendship, chant of the nation
we are all scattering a dance of dispersal
lashed with the barbed wire of connection
gathered in a ritual act of abandonment
leave me alone, leave me alone, leave me alone

I see it now in my son's eyes,
etched in my lover's stance
The flesh of this enchantment
is despair

I have been caught up in running
in the very wrong direction
for freedom

Fleeing, like everyone else
rushing pellmell
into isolation, it is an armless
sort of freedom
cold
lacking nurture

"Given birth but not nourishment,
we die"

The old ones set themselves up
took a stand against nature
with very cold minds or passionate hands
they re-enact Enchantment

I am upon them nearly with them
rocking the infant instilling the beat
I heave myself backward and drop
into the chasm

I am created by
goddess and god

They create me that I might recreate them,
and so on, and so on

I refuse an early death
but it won't leave me

I eschew a half-life, yet
informed by the chant in my bones

I carry the twins of wrong way/right way
in perfect balance, afraid

to tip the gods of war
who rest inside me

O Goddess of the Crossroads
I am at your door

take me as your channel
take my eyes, take all of my fears
and desires

Push through me
Make me *your* instrument

Play on me
a few true notes
of freedom

MULTIPARA I

Downtown Eastside & Taipei

1990–1992

Proud Belly

proud belly sits cross-legged
at the seashore, fat lotus

rosehips thicken once the petals
have spread

proud belly walks through
city streets, erect

a proclamation

when I was a child
the mothers were identified
by their eyes, blue-black
or greybrown hemispheres
below dull or intensely bright orbs
lidded with pain

the shapes of women's bodies
were mysteries, under clothes
was foreign territory — we have
forgotten where we come from

in those days
mothers belonged
to other people

I remember my mother
her coffee cup and her ashtray
balanced on the orb of her
clothes-over-belly

her cigarette a burning wand
that drew a sacred space

the smoke was an incense
I as a child would gaze across
study the overall picture
the icon

peer into that tired face
memorize
those eyes

as a *primipara* I looked down
on thickening breasts
on burgeoning belly

what the mystery was
I'd let through the gates
now taking shape

losing sight
of vulva, knees, feet
my part of the street

as a mother I can also look up

see myself with a child's vision
up past columns of thigh
flattened mound of pubis

over waxing belly
into purple-tipped fountains
of nipple

on to a face
familiar one of a vast array
and special

in the belly of the beast
in a structure built of
beastly bones

in a shelter of bodily fire
in a web of flesh
in a landlocked body
of water

there grows

in me
there grows

Great Mother

the babe in my belly feels
just like a great idea
burgeoning, taking shape
swelling up in my mind
taking up more and more space
until
all that remains
is the urge
to express —
but we're not there yet:
I am singing Our Name
laughing with a great idea
growing in my belly

I feel like a vessel
I feel like I am who I am
but a container, too, I have
pushed to the limits of my form
and become a great structure
I am edifice

inside, another one burgeons
two of us, Life:
in the eyes of others we may be
inseparable, but my great idea
already has consciousness
living in a body in a body —
I have my own body too
I include the new life
as She includes me

feeling Her
in every move I make
bigger than me, She moves
right along with me:
I am embodying Her
She is inspiriting me
We run the great circle
together
Laughing Our Name

Reprise

My belly is swelling
there is no end to this
over and over

a limb that is not quite mine
rippling surfaces body and mind
I am all moving over

all of me
moving over

all of some body
unknown
growing inside me
growing alone

but completely
within my domain

new flesh
new bone

rolling in a sea of rhythm
pulsing placenta

pulse of breath
and of heart

Birth/Wide/Spread

thighs widespread
a compact head
coming down
out of my belly
into

World

this is the first descent

within the context of
my body
formlessness bestirred herself
into form

a whole true human
doubly embodied
then moving down out of

my wide open vulva
my cunt
my lips spread so wide
they might split

the crowning

Energy

I am pulling down from the sky
through the crown of my head

the gift of goddess is
the miracle of body

the miracle of birth and body
the miracle of energy channelled
in a straight line
from crown to crown

through me

the complexity
of becoming

we may never be
this close again, but here
pure
a primal moment
head sliding snug against
cunt/muscle/bone

small cheerful sounds
you are making
I am hearing
your mouth
still enclosed in me
words of parting
greeting

birth/wide/spread

with passage of the head
the hard work of belly and hips
is done

your slippery
body leaves

a wide wake
of pleasure

passing through me

Old MacDonald

old macdonald
had a baby
a e i o u

out by the barn
where the grass is wavy
a e i o u

y y y
y y y
macdonald had a baby
my o my

old macdonald
had a baby
a e i o u

Song About

this is a song patterned
after a song sung
for centuries

maybe you recognize it

it is a rhyming song
but the rhymes are
in another language

maybe you can hear them

it is a song sung
by a native mum
to her babies

maybe you recognize her

she sang it to her baby who
sang it to her baby
who sang it

maybe you remember her

she married nice gaelic men
she married herself
into the white race

maybe you recognize me

she sang it to her baby who
sang it to her baby
in silence

maybe you can hear me

this is a song patterned
after a song sung
to a baby

maybe you recognize it

it is a song about
it is a song about
a sound caught
in a mother's throat

it is a song about
it is a song about

a song caught
in a mother's throat

it is a song about
it is a song about
it is a song about

Am

Am lies on her back on her bed with the covers thrown back.
She slides her ten brown fingers down her long, lean belly,
curves up the two flanking hills of her pelvic bones, pulls
her fingers back again dragging the nails so lightly along her
bellyskin, sends fingers sliding straight down to her pubic
arcing bone with her hair her black tendrils her wee forest
on the hill.

Am in need of stroking, strokes. In need of tickling, tickles.
In need of attention, attends, until like a restless she-lion she
pulls up and tosses on shirt, shift, shorts and moves out of
her space, out of her place, into the wide world whirling she
prowls, prowling. Keen eyes clear and restless. Pacing through
the heterosexual streets, testing the wind with her nose,
tasting the scents on the breeze and looking for action.
Looking for no-trouble. Am one is looking for am two,
another body to run her waking fingers over, other fingers
to move her bellyskin and bones under, another breath to
catch and sigh to ripple the air with, am one listening for
the interweaving songs of am two, am two calling.

Am lies on her back on her bed with the covers thrown back.
She slides her ten brown fingers up the long tight mountain
of her belly, curves down the sharp round sides of the moon
and dribbles the tips over the little dips and climbs of her
pelvic bones. She pulls her fingers back along the underside
of the planet that strains for the sky, then up and over again
the dizzying heights of her own stretched tight bellyskin, finds
the little growing hole where her belly button used to nestle,
lifts her shoulders and head from the bed to find the grassy
field on the boney furrow below.

Am in need of stroking, strokes. In need of attention,
attends, until like a restless she-lion she rolls herself onto all
fours and rocks out of bed, wraps a swatch of cloth over her

fertile swellings and heads off to the sun-drenched porch and the yard beyond. The streets smell of hot tar, the car fumes sting, but the yard is green and flowerbright, and the blue sky searches for miles for a bit of fresh sea or mountain clean air to lay at her feet. The people come to her. They come to her now, to see how big she is, to be maybe the first to see the baby still wrapped in its inside-her-body smell and to smell that smell, to take part in that miracle of inside-outside, of two knocking bodies triggering a whole new something unique that may blossom into humanity. The children poke her belly-button, the adults place their hands on her belly and wait. Everyone thrills when the inside child pushes head arm leg or bum in a long rippling wave or taps out a message on the stretched hide bellyskin of its very own mother. Am surrounded by words and silences, nourished by the depths of everyone she meets. Am crowned by the life that has chosen her as its center, life within life within life, spiralling, mandala.

Am lies on her back on her bed with the covers thrown back. She slides her ten long brown fingers down the quilted bed of her belly. In her ear is a tiny mew and like a she-lion she throats a wordless response and luxuriates, rolls onto her side and sniffs and licks the little being. Nudging her full brown tit up beside the tiny living face. The face nuzzles and slurps, arcing its tiny body against her and using all the force of its being to pull the nourishings in from the older bigger body and mind, into its own growing being that swells with immediacy: HUNGER (sigh) satiation SLEEP (ah) mmm HUNGER (sigh) satiation SLEEP (ah) mmm HUNGER . . . Am caught up in a smaller rhythm of life, many days and nights within the larger days and nights, many lives and deaths and births and changes, many sniffs, many sighs, many breaths.

 Am in need of stroking, strokes/the infant. Am in need of tickling, tickles/the child. Am in need of attention, attends/ the baby's every breath or pause between, every feed and elimination, every small accomplishment and skill or almost

skill seen or dreamed. In return her offspring never lies to her, never looks or smiles longer than it wants to do, and climbs all over her body and through her hair. Am soon will be restless again and go prowling, sheltering her offspring with the hot big rhythms of her heart. Am now curls up around the sleeping creation, gazes at the miracle, at the delicate miracle eyebrow, at the beautiful miracle skin.

Am strokes the tiny perfect long brown fingers of her bellychild. She ripples inside and feels again the head, the body travelling out. A long slow journey of forever. Thank you for sharing this. Thank you for coming. Thank you for parting my hair, for finding your way through the forest, fruit of my plowed fields and tender moments.

Birdsong

Bird weaves her bed of mud and grass
and if
there are people around
she borrows bits of plastic
and string

she structures a circle
concave and deepening
she makes a safe place if she can
she lives by the wing

she is offering
each day
a trust a hope a prayer

she has faith
this is a good earth
we are all good beings here
we are all in this someplace
together

we eat
we feed
we sing

we fashion our nests as we can
and there is death
all over the place
we sing about that too
we sing about the hard place
we sing about the easy time

we are the offering
to the ancestors
and the offspring

we are the hungry jaw
the killing beak
the dying grub
the grass and string
the birdsong

Unmaking the House

The cedar boughs are dry
only let their fragrance go
when the vacuum catches them, mulching
the cedar twigs, scenting the air

The Australian flower
collects dust, banished
along with the cedar
to the patio

The altar is gone, goddesses
and turtles and stone, chalice
and sweetgrass and sage, all
are packed away —

some into boxes
into storage
some into pouches and bags
and suitcases

to be seeds
for a whole new household
to grow up around

cross the great water
cross the great water
cross the great water

the time is soon,
or now

gather your children
sweep out the house
leave the broom
at the threshold

and fly

Little Flowers

Eating flowers
is better
than eating spiders

Children frown
showing me
my face

A Tip of the Table

it gets me at that place
where I am most alone
in the world
in the gut
i was thrown
into this world
everything was set up
long before i arrived

children can be broken
that's the scary thing

like a favoured vase
a pane of glass
by a tip of the table
or by putting your fist through it
children can be broken
socialized like horses
or just plain broken
sweep them away

sweep them away
all these
tears sobs groans
sweep the water from my cheeks
i bite from the inside
who wants you here anyway
by a tip of the table
or by putting your fist through it
children can be broken

it gets me at the place
where i am most alone
in the world
in the gut

i bite from the inside
who wants you here anyway
to be ridden like horses
or just plain broken

everything is sliding
everything has been sliding
for generations
sweep them away
by a tip of the table
by a tip of the table
sweep them away

Justice

My body is just a place
that memory calls home — a long
twisting pattern of thought
snaking back through the minds
of ancestors —
passed on through their bodies
through
and through
and through
until I am formed and born
in a present day world

and in
bearing children
I am pushing thought through
dragging those prehistoric impressions
through
and through
and through
those doorways of flesh
to burble forth into
some future
time and place

those things
not resolved
in one lifetime

will never be
surrendered
at the grave

Our Mother

O my goddess
i am heartily sorry
for having stumbled over thee

forgive us
our trespasses

we forgive those
who have trespassed against us
and we are breaking the chains

our Mother
who art the Earth

holy be the ground of our being

Migration

The most recent thing

simply tugs on a rope a long
chain of similar
things that
were we trees and cut in half
you could read by the rings

these things

incident upon incident linked
by the essence
the message
or by an image
sensation

because you are female
because you are Indian
because you are smaller than me
because you inconvenience me
because you're handy

you are in danger
I am your danger

Roots:

the fingers we plunge into the soil
of our worlds

every time I cried and was safe
every time I was endangered and saved
each and every gentle human contact
that is made

one of my roots is the moon

another is the taste of cold weather
the feeling of a warm sun
the sound of rain
and of thunder
the feeling of a strong wind
big sky
snow
earth
the colours of plants and trees
the quiet crackle of autumn
the feeling of me
the sound or scent or sight
of favourite people

And these are the chains:

the curve of a white shoulder
white breasts
a man's round belly
something approaching fast from above
or before or behind
not believing me
looking disgusted by me
no one looking at me
everyone looking at me

The forest
should stand
many lifetimes

but sometimes, I just can't

in preparing to go

for the first time I am pulling
my roots up gently

rattling my chains on purpose
not ripping up and tearing off

only to be brought up short
in a stunning cessation

Rock

rock-
a-bye baby
on the tree top

when the winds blow
the cradle
will rock

if the bough breaks
the cradle may fall

but I'll catch
my baby
cradle

and all

rock-
a-bye babies
on the tree tops

when the wind blows
the cradles
will rock

and if the boughs break
the cradles
may fall

but I'll catch
my babies
cradles

and
all

rock

MULTIPARA II

Richmond & UBC

1993–1995

Spiders & Dogs

listen to
my wail song

what was born
in the meadow
was a spider

pulling the stuff of her being
out
where it belongs

into the World
into the neighbourhood
into the meadow

anchoring
the stuff of her being
onto the grass that came forward

onto the stone that came forward
onto the stem that came forward
onto the twig that came forward

onto the earth that stayed beneath her
under the tree that remained
standing by

do not break this web
it is so tender

yet if a dog passes through
it can be built again

what if a dog walks through
what if a dog does
wander
into the neighbourhood
what if a dog comes
into the meadow

will you feed her?
will you give her water?
will you take her away?

and who will you be robbing
if you do?

as the aunts
walk over me
I will tell you

I was so frightened by the dogs in my dreams
I created flight

I was so angered by this fear
that I broke the dogs' jaws

over
and over
and over

broken dogs
littered
my dreams

this dog
is speaking to you now

this dog peers at you
with spider eyes

this spider will not wag her tail
or lick your hand
if you come to take her

trust
inspires
trust

everyone who dares
to come forward
is welcome

we are all of us
spiders and dogs

if you cut the dog out
you break the web

and it will come back to you
because it is you

we are altogether bigger
than our wildest dreams

let the dogs pass through
that is sacred

listen to termite
who goes about her
ordinary life

Healing Circle

With unbelievable tenderness, you
wipe the tears from my face, the sweat
from my brow

you encircle me with the blanket
that has encircled many others
before this time

red candle burning, smudge fire
smoking for hours, drum
and feather

crystal making the slow
round of our hearts falling open
together

after I lay down the tears
carried for so long, and mourned
the brokenness

still, you waited

holding my two hands and calling
in the healing presence
of Mother Earth, of Creator

encircling me with your warm bodies
to remind me of the truth
that I am not alone

preceding my words with your words
my sorrow following yours, your words
coming after me

dark room of long quiet
slow voices and warm
gentle hearts

you extended to me the same
love the same time the same
presence

as to each one here

beginning the circle
and ending the circle calling in
those who need us now

history is long, the world
both fierce and tremendous,
one person alone

is so much easier and stronger
when she joins within the circle
of her people

in the presence of Great Spirit

and recognizes, home

Remember

Remember that you are
a good woman
grown from a perfect child
remember
all of your hopes and dreams
not forsaken
still possible

Remember that you are
completely deserving
all of the love in the world
is the web
that you stand upon

Remember that you are
a smart person, and wise
your feelings are an essential guide
the clear heart of matter
beating out a rhythm
we can all dance to
you are the groundwork
a house, a loom:
all of us are weaving
our lives around you

Remember that you are
a full woman
remember
you are not
alone in this place
remember
all of your needs
all of your hopes
all of your dreams
are a potent fire
warming the world
lighting your face

Grandmother Sweatlodge

learning
returning

it is not fear of the dark
but of your wet heat

which may be the
wet heat in me

i crawl
from your womb

nourished
in surrender

i give thanks
for the lean shanks

of community

Ma

Vagina the street
and vulva the gate
opening both ways

within the walled town
or sweatlodge heat
feel me again

my bellyskin
the drum i beat
sounding through air

that boggy place
vessel of life
home and lair

that slippery place
the gateless gate
passing you on

glimmering breasts
to suck on and rest
starved then secure

powerful legs
to use as a guide
until you can stand

the stuff of which
life is made
i shake from my hair
i shake from my hair
i hold in my hands

INTERREGNUM

East Vancouver & Richmond

1996–2000

Birth Sketch I

This woman is
torn open: the brooding power
of birth leaves
a yawning gap
between her thighs
face wrenches

yet
intricately inside of her
dance all the living creatures
of the world
suns, moons, thunder beings

quite separately
the lone infant
lost in a field of white space
falling

Birth Sketch II

simple solid woman
hunkered down, hair
escapes the ponytail
a few wet tendrils

below
the human child
just now leaving
this mother's body

outside the circle
rendered down to two
delicate hands
is the father

he who was so
important to me
and so central
sidelined

A Present Made

o those hopes and dreams
sweet days and troubles
walking side by side
past flowing streams

pebble beds turning
catch glitter of sun and throw
star glints, moon beams
o young man of mine

down city streets you walk
hunkered in black leather
against the rain
we move and

lovelights shine on
cardboard boxes
souvenirs of what appealed
collect, define

o unexpected
gifts of life, cruelties
and cowardice fade
we who, so excited and afraid

looked ahead
now stroke the braid
of all we've done, intended
unintended

each, and all together
a present made

The Kitchen Thief

I was in there, preparing
food and you

just couldn't stay away
I told you

back off and give me
some room

so you stepped back
two paces

still I could feel the weight
of your gaze

there on my hands as I worked
in the kitchen

anger rising in waves, my
false smile glistening

you across the room
and watching 'til

I felt like a thief
in the kitchen

watched by security
watched by security

my hands slowed and
my hands slowed and
my hands
stopped

I surrendered to you
the kitchen domain

for a full decade
I became

a guerrilla chef, secretly
cooking

Birth

I. GIVING BIRTH

ten years ago
i did this
ignorance and fear
holding my skin and bones
so close
i was
tightly woven

spring in the form
of an old man infant
surging slowly through
burrowing
wakening
carving a way out
into the world

five years ago
i did this
standing on my toes
then coming down onto
the palms of my feet
to be solid and strong

being as big as i can be
holding my ground
making space
for the arrival of
an old man infant
in the sudden pale guise
of a thunderbolt

two and a half years ago
i did this
hunkered down in a rented tub
kids at summer camp, we were:
a baby is coming, a baby!

family drifting through
the house, children
swirling
up and down the stairs
as an old man infant

drifted and swirled
into our world

four months ago
i did this
i called upon the grandmothers
to be with me
i know this task
with every fibre of my being
i open close

midwife talking me through
says, it is safe
for you to do this

and the grandmothers
colour her words
it is sacred for you
to do this
sacred

II. SHARING BIRTH

near birth: we are scared
we do not trust this thing
the doctor says
you can do it
we say no

we honour the life that passes
unborn

first birth: we say
we can do this
maybe we can do this
i cling to you, my
desperado-nurturer

i hang my tired self
from the steady frame
of your bones

second birth: i clutch
your two hands in mine
stare deep into the
dark safety
of your eyes

i stand alone
you walk around
greet the child

third birth: you come
for the last time
naked with me
into the birthing place

guide the child

fourth birth: you stand near
not entirely with me
draped in more than clothes

i surprise myself
by calling your name out loud

all of our grandmothers
are here

all of our grandfathers
are standing behind us

all of our children are waiting for
this birth

Protection

where is the flower
within whose petals gently folding
i may sleep safe, hidden
from the great night

so small and vulnerable am i
these delicate legs and wings
require profound and golden light
to carry me

tasting nature's menus
through each day, averting
certain dangers and inviting
certain play

still, at nightfall
when flowers sleep
i am too naked to survive
and starlight too weak

Gone Not Gone

With the kids gone
I sleep in a messy house

that I may wake up
within the illusion

not gone

Separation

My parents are like
crows in the trees who
throw down their voices

Some birds will bounce
right up to you
eat from your hands

But those crows call
and come just so close
turn heads to examine

if you throw food
they will bounce away
take flight

My sons are like flotsam adrift
now seen, now gone again

I do what I can to
gather them up

and fail,
and fail again

My sons are like sweet promise
on the horizon

beauteous colours that enchant
I do not know

do they rise?
do they set?

My husbands are like
the end of the night
in the bar room

after all of the pick-ups
have happened
the partiers gone

My husbands are like
a thousand echoing chapters

row upon row upon row of him
sitting

head in hands

Mother's Day

we said
we would go
to the zoo

i was waiting
waiting

everyone else knew
what you planned

no one told me
no one told
the children

not your mother
not my mother

not your sisters
not my sisters

the children with their cards
and handmade gifts

waiting
waiting
day after day

on the phone
they beg me

why can't i see you
why, why can't i be with you
i made you some beautiful gifts

for Mother's Day

Night Flight

you are all calling
back and forth to one another
as always when i hear your talk
i walk out of my house

goose call goose call goose
the part of me
that is goose like you
always hears and responds

by drawing closer
close as
close as
close as

i possibly can

goose call
goose call
goose

i possibly can

one night
when you are all gathering
on the marsh
and when you all swirl up free
for a quick

night flight

my wings will pull free
my voice
will talk with the right
goose words

finally

Thirteen

like a shaggy bear
on the bench in the booth
beside me
he turns restlessly
lays down his head to sleep
then surges up
and orders another plate
of food

I listen
to the poetry man
sing out his heart for his mom
and hear this boy-bear beside me
sucking the last drops of water
from his glass

O Very Young

He asks me, *What does "orphan" mean*
and, after listening
he says *oh,*

so what do you call those people
part-man and part-woman,
or part-boy and part-girl,
you know

He says, *look what I have*
and shows me a plastic trinket

Yes, and look
what I don't have
his little brother exclaims
with wide, empty hands

I will play for you, he says
crosses the yard and climbs
the tree

blows his harmonica
so sweetly

As a Good Jaguar Should

today I have been
a good mother
my son and I
spent time among
the trees first
I taught him
how to climb a tree
then I taught him
how to kill a goat
then I taught him
always to drag his kill
off to a private place
to feed
and to snarl
at untimely visitors
as a good jaguar should

Decade One

There was a time
when I worried
that the rest of my life
would be spent
drawing little dinosaurs
at your request

I worried
I would be changing
your diapers
forever

Those worries passed
half a lifetime ago
new worries trickled in
swelled
passed in their turn

What I learned from you
stays with me, your little voice
moaning, *all right*
I will
teaching me over
and over again
about domination

Your look of wonder
sitting up in bed
when I, exhausted
by your endless river
of words, asked, "Can't you
lay there quietly
and tell yourself stories
in your head?"
I didn't know
I could do that
you said
our world changed
ever after

The lessons
in precision, like the time
you asked to nurse and I replied
"we need to lay down
for that," and you said *okay*
and stretched out
on that grey suburban sidewalk
ready for me

And all those tender hours
spent with your brothers
the elder, the younger,
your father
your mother
calling us out
inviting us in
wandering off without us
circling back
- again

Love when you choose
is a palpable, focussed flow
like the jetting stream
of a firefighter's hose

Articulated wit —
you can bring us to the edge —
a power you are learning
to discriminate with,
use with discretion: less and less
do you find yourself
calling forth
unexpected storms

You arrived
in our lives
in a great hurry
like a thunderbolt
descending
into a family dance
of humour
and of love

When I hurt
I want to bite
and this was true
in the deep of the night
when you were born

"I need something
to bite on," I said
and your auntie, dog-lover
that she is
disappeared from view
then returned
with a rolled-up newspaper

This I declined
so she took it away
and pulled from the closet
a blue plastic oar
for me to gnaw upon

Again, I eschewed her choice
and thus in the very moments
of your birth
I had to pause
and think very carefully
about what exactly it was
that I required

"Please bring me
a clean
cloth diaper," I said
and she did
and I bit down
and you peeked out
and your dad
made of his hands
a cradle
to catch you

Every bit as much
as you were wanted then
you are wanted now

Every bit as much
as you were integral to us
you are integral to us

Ten years old
may seem like
neither here nor there

But you are a boy
resplendent with joy
and I dare you

to show yourself
to the world
to shine your light
to celebrate
as I most definitely do
your life

Remember when I bought
all those dictionaries
last year?

Grab one, son,
because I want you to know
exactly

what is in this
birthday package:
Love, your mom

Springtime Blossoms

I tug my widow's weeds
about myself, the springtime sun
strong enough to permeate these clothes
woven against
sadness time

instead of your worries at night
or your generous sighs
I listen to the hundred voices of frogs calling
inhale the scents of blossoms, every year
they come back
with or without you

I can observe families at playgrounds
and taste again all the love sweet joy
you brought into my life
with your fine-stepping ways
your elegant hands

bitterest days and fear and rage
like old snow have faded
pelvic bowl
that welcomed you
pools sorrow

instead of telling you my dreams
or just rolling over
I sit on the porch, regaled
by one hundred thousand morning birds
singing
inside the house
and out

Grandmother

hawk
starling
robin
crow

through springtime dawns
where winter cold
sighs and fades
and summer warmth
draws near and
takes place

morning after morning
opens grey
buds swell into presence
birds shelter in the wind
songful
full of quarrel
commissioning with voices
the coming of the day

my grandmother
lay dying
someone's infant child, parents
long fled
someone's adolescent girl
long pants in the snow
jaunty tilt of head
someone's bride to be
in courtship by the pig sty
fence
someone's young mum
someone's middle aged

domestic
someone's
old woman

your father loved
to sing
your husband played
the piccolo
your children sang
in church choir
your granddaughters sing
across the final hours
of your use
of breath

my grandmother
lay dying
all of the ages of self
gathered onto one bed
an old, old woman
with handmaidens
who loved to touch
her face
and the crown of her head
who loved to kiss her forehead
her cheek
her neck
as she had done for us
countless times

no longer will I search
my grandma's pockets
for a treat
I search your sightless
eyes
your falling silent
breath

no longer will I see
the bright lines of laughter
dawn across your face
while life still moves
between us
I hold your hand
I love you

a final chance to be with you
in life
all I can do
is watch
and touch
and sing
the final evening

soft as a caress
grandmother
has flown

Mother Time

sweetgrass hair
moss eyes
matriarch of clan

bends berries
folds dried leaf
all of us follow

her lead
echo
her mind

bodies
tracing patterns
she enacts, protocol

running thick, then thin
then thick again
through millennial time

small changes weave
the old
into the new again

braiding
youth, maturity, great age
cycling seasons

now it is fish
now it is digging sticks
and roots

now it is fruit
now it is home repair
and the snowbound truth

dress for a small child
feast for a clan
dancing slippers

tea for a treacherous cough
song for a broken heart
laughter

she can make
each of these things
at the proper time

given community
a perceived need
and an ear tuned

to those who walk
beside us
all the time

MULTIPARA III

Richmond & Seattle

2001–2002

Conception

He lifted her flowered pocketbook from the small pub table that rose like an island between them. He grasped the small metal tag on one side, and slowly unzipped the wallet, up, across, down. Looking inside, he found the second, inner pocket, and touching the small metal tag, delicately, he opened the zipper.

He reached for the coin on the table, picked it up with his pale hand, and placed it inside the inner compartment.

She watched him, transfixed.

Slowly, he closed the inner pocket, the coin held safe. Then, still with a gentle hand, he closed the outer zipper. Finally, he placed the flowered pocketbook once more on the table between them.

She looked at her pocket book for awhile, then looked across the table at him. He met her gaze for a moment, then glanced away.

"So," he asked, "shall we go?"

"Yes," she responded.

She picked up her pocketbook, all dusky rose, and held it close to her breast.

"I am ready," she said.

In Autumn Garden

in October fields
I sit
all around me
the summer fruits
are plucked
and hauled away
their residual greens
of leaf and stalk and vine
become yellow
brown
black
and die away

in October fields
I sit
slow I ripen
on the vine
my colours deepen
my fruit
thickens to round
as the gardens
quiet around me
and the gardeners
put each plot to bed
then turn themselves
away
with thoughts of tea
in winter kitchens

in October fields
I sit
a harvest moon
on a frosty day

A Moment

I stand naked
outside the bedroom door
breasts smooth and
purple-tipped
belly huge
with child

You are inside
the bedroom
bending over
your black bag
half dressed
already

Who is This?

who is this?
even now taking shape
in the warm sheltered
and musical place
inside me

who is this?
as you grow you also
tear down, remaking
the one-person one
now become your father

who is this?
 sexiness
 insecurity
 gladness
out of this, you have come

calling upon
our far-reaching
telling us to

oh grow up
draw together
close the gap

catch you with a strong
and so familiar net
when you are ready

your brothers
slide into position
your mother
glistens with joy
your father

prepares himself
for the day
when you
come tumbling
manifestation of magic

when you coast gladly
into our world
 who is this?

Birth Place

that low instinctual place
we like from time to time
to draw upon
is calling to us now
calling us in

allow the outer forms of life
to slip
like old skin
drop down
drop down
burrow in

down here the scent
of earth and flesh
grows stronger
windsong
of the blood
is calling louder
louder than the rain

overhead
the buses roll
the school bells ring
clocks tick
bills
must be paid
but we have dropped
in

at the bottom of the garden
in a time of seclusion
we drop down individuals
we rise up
a whole new being

Reproduction of the Goddess
in the New World

young boys
take me aside
one by one

for private
conversations

one day
each one asks
could she be

a mother?

GRANDE MULTIP

Richmond

2003–2005

Two Children

she assigns herself and then
takes on each challenge with
new vigour her brother's name
like a chair she will learn
how to climb, and
a table to sit on

like the bark of the arbutus
his child self falls away
in ragged patches
he lifts his sister high
he plays tall adult
to her small ambition

Invitation

child encircled by my
all of me my everyday
o child

sit this night with me
this one night more
upside down inside
and warm
in darkened garden

beneath the full moon so
high in cloud-dusted sky
o child peace
before the pain-filled
tumult of release

o child
sweet milk awaits
all of life beckons

Tableau

The man grabbed me
from behind

I grabbed the woman's head
with both my hands

Head down, the boy
charged

Two steps inside the door
a baby is born

Wave

I lean into your small gaze
I am not afraid
you look your questions
I answer with a wave
of tenderness

Easter Feast Day

a very young girl
looks around the circle
of faces at table
and speaks:

two dads
a whole bunch of kids
and one mom?

Is that what we have?

Multiparanormal

1

Flora Jo: goddess of spring, god

she sits on the floor with a toy
called happy family:
mom, dad, child, house, dog

she plays for awhile and then
she begins weeping:

well
where is everybody else?

2

Isidore: gift of Isis

every minute of my life
is agony, he cries one night

I must be the luckiest boy in the world
he says, one Christmas morning

A small child who, through tantruming, pulls
a whole school around

makes it more comfortable
for himself

A child who, through luck
and through agony,

grows

3

Theodore: gift of god

he slips into the family
like a sigh

he instigates
song festivals

he will play with anybody
anything: art, stick-fighting, risk

yet still he must slip away alone
to the schoolyard, to the headphones, to books

he is so eager to do the right thing
even reprimands are cushioned

in apologies
and in praisesong

4

Harper: minstrel, maker or player of harps, named for Elijah

In Taiwan they called him *hen ke ai*
and posed beside him

today he calls himself *haibishonen*
reads comics on the internet

takes language classes
on Saturdays

tosses his long, long hair
and works, and dreams

Hen ke ai, very loveable (applied to babies), Mandarin
Haibishonen, yes, pretty boy, Japanese

5

Stuart: caretaker, steward, royal family name of old
(Scotland and England)

As the firstborn child, he had to invent
everything

from the first cell divisions, every move he made
was a shock

he has worked hard in realms of
parental co-creation

negotiating the terrain
building, teaching

carving out a protected place
for self

6

Jules: of Julius; "jewels"

he falls and cracks his teeth, and all summer long
piece by piece they break away

he was born with two dark eyes, one slightly smaller
my dad says, *that's perfectly normal*

my mom calls it,
the Arnott eye

Jules is contented:
he loves our ways

songs spill out
in his mobile wake

he watches Stuart play guitar
the way I once watched my dad play

when he doesn't like what his parents are doing
he cries, *Harper*

Theo and Isi are good for bouncing, dancing, wrestling games
and rock music, leading inexorably to deep sleep

Flowa Jo is his constant companion, and constant refrain
from barbie dolls and dance parties

to wagon rides and mudplay

Into Manhood

Although it seems to me
when young men arrive
grown men turn away

and there is no hand
into which I can pass you
now you are come a man
except your own

and even though I dream my dreams
of a shaken earth
dream you back into
a small dependent state

even so
even so, I cannot grasp you

When young men go roving
their tangling loyalties lead
to pain, and to trouble

the constable stands beside you
explaining your actions to me
as my heart breaks
and tears
flow down your face

I see you sit, head bowed
bathed in the monitor's glow
your songs and pictures are gleaming
across the world
to people unknown

and still, from time to time,
you lift the guitar in hand
and stoop
to kiss my cheek
in passing

and still, I shake that dreamland tree
and from it fall
sweet dreams for thee

like ripened fruits, ready for harvest
ready for your hands

Boy of Earth, 1986

at the beach, your round head
circled by the woolen cap
your dark eyes, your infant
eyebrows, your
attention focused
on me

I build you a humble castle
of sand, more like a cone,
the autumn waves sound
in our ears, the wind
in off the ocean
touching

you look so impressed

I build you another, just
beside the first one
I smile — your face
is alight — yes!
these are for you!

you bow down in delight
your mouth encircles the tip
of your chosen mound of sand

you nurse — but just for a moment

my shriek of horror
at our misunderstanding
the wind carries it away

my fingers empty your mouth
of the crumbling food from your
earth mother's pap

i offer human milk to wash you free
of every lingering grain
of betrayal

while horror and contrition fade
in the gentle repetition
in the sounds of the waves

amazement
trickles through me

I embrace you, boy of earth
child of mine

giggling

NOTES

On language: I have used many bold words in these pages to name the *sacred scoop*, the female parts: here now I will reveal her true name, as taught to me as a little girl, by my beloved mum: *little bum*.

On neighbourhoods: The experiences of life unfold in particular places, and unique neighbourhoods bring their own influences to every household. For these reasons, I have indicated in the section heads the places where we lived, and I wrote, over the years. Since migrating to the West Coast, my mainstays have been East Van, the Downtown Eastside and Richmond. Taipei was my home for about seven months. I lived in Seattle on a part-time basis for two years.

On medical matters: Jules' patio accident occurred at a time when our children's provincial dental coverage had become inexplicably locked: yes, they qualify; no, the bills will not be paid. After a summer's endless cycling through bureaucratic mazes, I sent an email to the premier of the province. Coverage was quickly reinstated.

On assimilation: In the early '90s my friend Flo said to me, "Who will teach our children the songs? How will we teach our children the songs? It's too late!" As a mixed-blood person raised in white communities, I can only pass on what I have received, observed or invented. I refer the reader to the many other Métis and aboriginal writers and artists at work across this land, many of whom can and will *teach our children the songs*.

GRATITUDE

The teachers, guides, helpmeets, associates and friends over forty-five years of life are innumerable: a whole book of gratitude could be written, simply by naming names, and saying thank you.

My grandmothers and my grandfathers have all had profound influence on us, through the choices that they made, and the silences they kept. For the children that they were and the ancestors they have become, I give my thanks in all of the languages of the heart.

For my parents and all of my aunties and uncles, sisters and brothers, cousins, nieces and nephews: deepest respect for the paths we travel, and my thanks for the safe return of my inner conviction of devotion.

For my husband Nick Zenthoefer and his parents and siblings, my thanks for shared time, shared love, and shared teachings. For Brian Campbell and his parents and siblings, again, my thanks.

For the young people who have come to us, my thanks for permission to share those poems that primarily concern each of you. My thanks to the older children, for considering and speaking on behalf of those too young at the moment to care. Although I've warned each of you not to consider reading this book until you're well past forty, this text is not rigged with sensors or alarms.

Particular thanks to my son Stuart for your generosity of spirit, for your courage.

Kateri Akiwenzie-Damm, Gregory Scofield, Nym Hughes, Marilyn Dumont, Maria Campbell, Connie Fife, Lee Maracle, Beth Brant, and Daniel David Moses are among the writers who have intervened in my life in positive ways, and provided timely sustenance. I give deep thanks to each of you, and send warm greetings to my friends in *The Aunties Collective.*

For Ron Hatch and Sharron Proulx-Turner, my thanks for your help with and your interest in "my opus." For Shandra Spears, thanks for reminding me, "Writing does not just capture a slice of life. It can change a life."

Warm greetings to Ellen Antoine and to Grandma Harris, met through the Indian Homemakers Association. Other outstanding teachers over the years have included Flo Robertson, Peter Chau, Jake Klassen, Sheila Sherban, C. Lee, and Sarah Davidson. The late Gayden Hemmas taught me how to link all that is most wondrous with all that really sucks, and to carry on in a more balanced way, a core teaching. My thanks for Rain Daniel, the woman who fell from the sky.

To my midwives: through the changing legal landscape of midwifery in BC, my thanks to each for your clear-eyed gaze and consistently informed support, performing mother-centred care and allowing family-centred birthing experiences. My thanks for tutoring me in the languages of childbirth.

To the many caregivers who have worked with my children, from the ladies at Crabtree Corner, in the earliest days, to family daycare owner/operators at work in the suburbs: for day-to-day support of the family, you were all blessings. Kirsten, your surname now escapes me, but it was for you that I first penned the poem, "Remember." To the women of Lansdowne-Murdoch Daycare, my thanks and best wishes.

Although I have had a few traumatic experiences at the hands of school staff, over time I have built wonderful alliances with people whose lives are dedicated to working with young people through the school system. Sincere thanks to my friends in the Richmond School District, and warm greetings to Mike

Akiwenzie, Lynn Wainwright, Barb Gawa, and Louise Walker. Special thanks to the changing staff who safeguard my son Isidore's learning and life, through collaborative work and school-team meetings, often slipping into our hearts in the process.

"Birth Sketch I" and "Birth Sketch II" were written as part of an international collaborative project of art-based poetry, a plaquetas project initiated by artists Nora Patrich and Juan Manuel Sanchez (and friends). My thanks to Nora and to my sister, Carole Gray, for the two original pen & ink drawings on which these poems were based.

To Micheline & Art Hamelin, my warmest regards: my thanks to Micheline for use of her image, "Creation at Its Best."

To all of the artists who correspond with me: your generosity as people is matched only by the splendour of your diverse visions.

Particular thanks both to and for all of my two-spirited relations, elders and children, dreamers and world-builders: *megwetch*.

My thanks to the Coast Salish People, particularly the Musqueam, Tsawwassen, Burrard and Squamish nations, on whose traditional lands I have lived for many years, where all of my children have been born and raised. Arriving as part of a centuries-long, ongoing, incoming wave, I was at first unaware that I should ask for permission, and then, aware of my status as an uninvited guest, unsure of how to do so.

At the beginning and at the ending there is our Mother Earth, our Father Sky, our need to honour and to be honoured in turn, and our ability to give thanks, to ask for help, and to give away: I give thanks for my children, and I give them away. Through them I express my pleasure in being born.

ABOUT THE AUTHOR

Joanne Arnott, a Métis/mixed blood writer, was born in Winnipeg, Manitoba. She has lived a cumulative thirty years in the Lower Mainland of British Columbia, as well as in other communities in Manitoba and Ontario. Mother to six children ranging in age from three to twenty years, Joanne has been a literary performer and publishing poet since the late 1980s. She worked for many years as an Unlearning Racism facilitator, and continues to incorporate social justice perspectives and peer counselling approaches in her work. *Wiles of Girlhood* won the Gerald Lampert Award from the League of Canadian Poets for best first book of poetry. *Steepy Mountain: love poetry* (Kegedonce Press, 2004), her previous volume, offers a record of a courtship year and a rekindled romance. *Mother Time: Poems New & Selected* is her sixth book. Joanne lives with her husband and children in Richmond, British Columbia.

MEMBER OF SCABRINI GROUP

Québec, Canada
2007